AMERI©AN DRE@M

Ronald Feldman Fine Arts New York

Distributed by D.A.P./Distributed Art Publishers, Inc.
155 Sixth Avenue, 2nd Floor
New York, New York 10013, 212-627-1999

Curators: Ronald Feldman, Martina Batan, Sean Elwood
Catalogue Designer: Rita MacDonald
Catalogue Coordinator: Laura Muggeo
Photo Researcher: Sarah Paulson

Cover: Pepón Osorio, *Fear and Denial*, 1997.
 Photo: John Lamka.

ISBN: 1-56466-113-X

First Edition
Printed in Iceland by Oddi Printing

There is nothing quite so American as the notion that we are self-made. Today as ever, hard work, high ideals, and pride of place nourish the American Dream. But we the people remain engaged in a communal enterprise. Our 18th century constitution (with its amended refinements) was intended to offer all citizens an environment in which personal dreams might be free to fail or grow.

But recently, it seems, something has changed. We are bombarded with reports of improper practices in our government, the economy, and many brand-name institutions. In addition, the country has been brutally attacked with one consequence being the erosion of civil liberties. The world, in general, has become more insecure, frightening and, well, disappointing.

Historically, many artists have chosen to record and comment on the issues of their times. We recognized that this was occurring contemporarily, but how serious and broad was this interest? Curators cannot invent such circumstances - they must occur spontaneously.

Very quickly it became apparent that a large number of artists share an interest in the topics of American culture. Using a wide variety of disciplines, media, and approaches, they are weighing in. The recognition of this confluence of creative practices and the subject of America provided us with an urgency to curate the AMERI©AN DRE@M.

Eventually, a total of one hundred twenty-one artists participated in the exhibition, either in one of the two locations or in the two evenings of film screenings organized in conjunction with the show. Limited by time and space, AMERI©AN DRE@M presents only a cross section of a much larger number of artists engaged with these issues.

Thank you to all the energetic, concerned, tough minded, independent, intelligent, irreverent (and perhaps even patriotic) people who helped make this exhibition possible.

Ronald Feldman, Martina Batan, Sean Elwood

Thanks to our acquisition of the remaining 50 percent of our European joint venture, AMERI©AN DRE@M is now one seamless company worldwide. For the first time since the original AMERI©AN DRE@M was established more than 225 years ago, we are one AMERI©AN DRE@M in Europe, North America and around the globe – one company, sharing one faith-based destiny: unlimited growth!

This transaction, completed April 5, 2003, served as a stirring climax to what was a truly unusual and extraordinary year.

In addition to celebrating our global unity, we rallied together to face extremely tough market conditions that were, in many ways, unlike anything we've experienced during our more than 225 years in business. The once robust U.S. economy, of course, had already begun to slow when terrorists attacked the World Trade Center on September 11.

But we are, after all, a company that has risen to the occasion time and time again throughout our remarkable history. From the Great Depression and various wars to countless challenges from competitors, AMERI©AN DRE@M has not only persevered, but emerged even stronger than we were before.

to our shareholders

01

31 MERCER STREET

south gallery

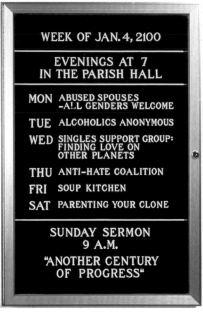

2

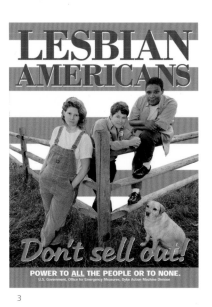

3

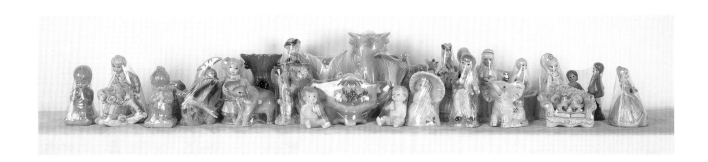

1

1	PEPON OSORIO	2	ERIKA ROTHENBERG	3	DYKE ACTION MACHINE
	State of Preservation, 1996		*Another Century of Progress*, 1999		(CARRIE MOYER & SUE SCHAFFNER)
	24 china figurines, shrink-wrap, cloth		aluminum signboard and plastic lettering		*Lesbian Americans: Don't Sell Out*, 1998
	14 x 90 x 3"		36 x 24" edition of 10		offset poster
	series of 4		courtesy Zolla/Lieberman Gallery, Chicago, IL		36 x 24" edition of 5,000

5

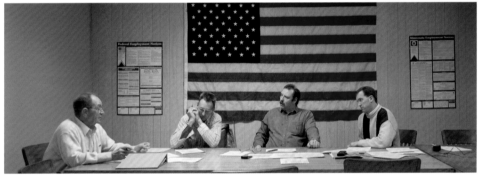

4

**TONG ZHI / COMRADE
OUT IN ASIA AMERICA**

★ ★

KENDAL

Artist, Afro-Korean, West Indian-American
Public Art Curator, Brother, Son, Lover,
Negative, 30-years-old, Partnered, Quiet,
GAY, Simple, Loves to Travel, Hates the Cold.

★ ★ ★ ★ ★ ★ ★ ★

**MUSEUM OF CHINESE
IN THE AMERICAS
NEW YORK CITY**

6

4 PAUL SHAMBROOM
 Lewiston, Minnesota (population 1,405), City Council, March 10, 1999 (L to R):
 Roger Layfenburger (Mayor), Denny Engrav, Gary Sauers, Rob Rys (City Administrator), 1999
 archival pigmented inkjet on canvas with varnish
 23 x 67" (F) edition of 5
 courtesy Julie Saul Gallery, New York, NY

5 MARK ROBBINS
 Bradley and David from *Households:*
 The Way We Live Now, 2002
 Iris print mounted on board, 5 panels
 14 x 44 x 1 1/8"

6 KEN CHU
 Kendal from *Tong Zhi/Comrade:*
 Out in Asia America, 2000
 letterpress printed poster mounted on
 museum box from a series of 20 posters
 22 x 14" edition of 22

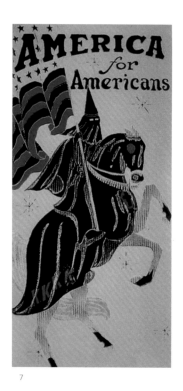

7

8

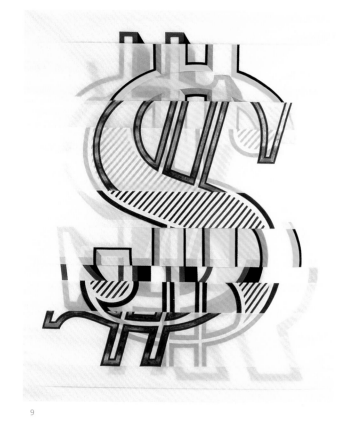

9

7 RICO GATSON
 America for Americans, 2003
 digital C-print
 27 x 13"

8 JAMES SHEEHAN
 Rush the Court, 1997
 oil on wood
 2 x 2"

9 JOE AMRHEIN
 $,1999
 enamel and gold leaf on mylar
 76 x 63"
 courtesy Roebling Hall, Brooklyn, NY
 collection of Greg S. Feldman

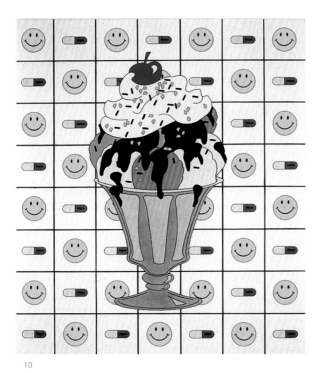

10

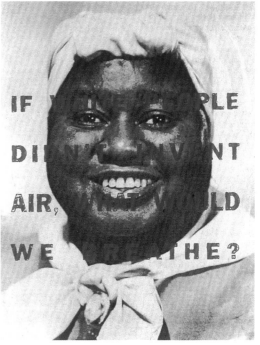

12

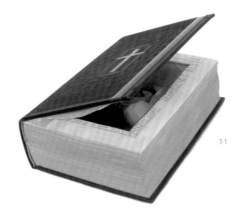

11

10 NANCY CHUNN
*C'mon Get Happy, Get Ready
for the Judgment Day*, 2003
acrylic on canvas
48 x 42"
collection of Greg S. Feldman

11 ROXY PAINE
Holy Bible, 1994
leather bound book,
drug paraphernalia
8 3/4 x 5 3/4 x 2 3/4"
collection of Martina Batan

12 DREAD SCOTT
If White People Didn't Invent Air, 2001
screenprint
32 3/8 x 24 5/8"
edition of 14

13 14 15 16

13 **JASON SALAVON**
Every Playboy Centerfold,
The 1960's, 2002
digital C-print
60 x 29 1/2" (F) edition of 5
courtesy The Project, New York, NY
and Los Angeles, CA
collection of Stephen Abronson

14 **JASON SALAVON**
Every Playboy Centerfold,
The 1970's, 2002
digital C-print
60 x 29 1/2" (F) edition of 5
courtesy The Project, New York, NY
and Los Angeles, CA
collection of Stephen Abronson

15 **JASON SALAVON**
Every Playboy Centerfold,
The 1980's, 2002
digital C-print
60 x 29 1/2" (F) edition of 5
courtesy The Project, New York, NY
and Los Angeles, CA
collection of Stephen Abronson

16 **JASON SALAVON**
Every Playboy Centerfold,
The 1990's, 2002
digital C-print
60 x 29 1/2" (F) edition of 5
courtesy The Project, New York, NY
and Los Angeles, CA
collection of Stephen Abronson

17

18

19

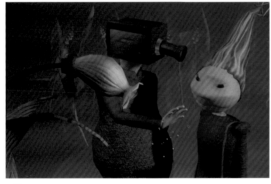

20

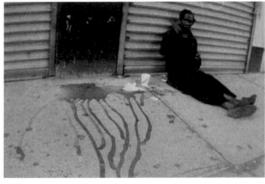

21

17	TODD DOWNING	18	SANDI DUBOWSKI	19	SAM EASTERSON	20	JAMES DUESING	21	ADAM COHEN
	Eleanor Starring FLLOYD, 2002		*Trembling before G-d*, 2001		*Where the Buffalo Roam*, 2002		*Law of Averages*, 1996		*Blind Grace*, 1996
	film excerpt on video		film excerpt on video		film excerpt on video		film excerpt on video		performance video
	3 minutes 33 seconds		4 minutes 7 seconds		4 minutes 17 seconds		4 minutes 46 seconds		1 minute 38 second segment

OSBORNE, AND TITUBA, A SLAVE, ARE ACCUSED OF PRACTICING WITCHCRAFT IN SALEM, MASSACHUSETTS —1692 MARCH 2 PRESIDENT

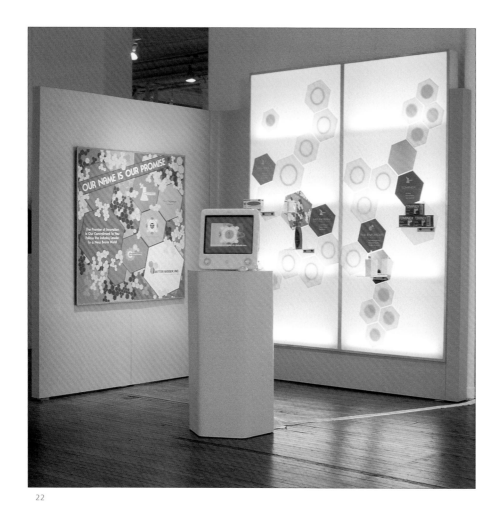

22

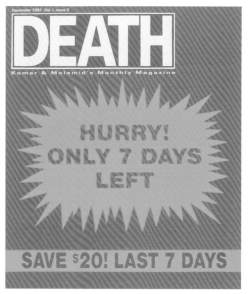

23

22	TANA HARGEST	23	KOMAR & MELAMID	24	ANDY WARHOL
	Bitter Nigger Inc.,		*Death Magazine,* Vol. 1, Issue 3,		*Be a Somebody with a Body*, 1985
	Our Name is Our Promise, 2001		December 1991, 1991-92		screenprint on canvas
	multi media installation		from a portfolio of 12 silkscreens		16 x 20"
	120 x 120" overall		12 x 10" edition of 250		Private Collection

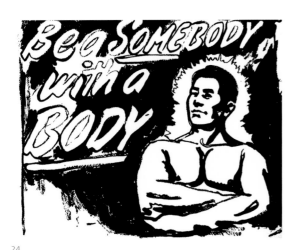

24

25

25 JASON SALAVON
Herotown 1, #1, 1998
Iris print
16 1/2 x 45" (F) edition of 6
courtesy The Project, New York, NY and Los Angeles, CA
Private Collection

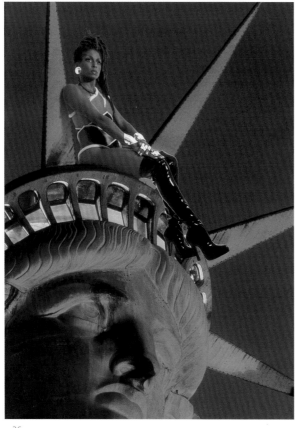

26

27

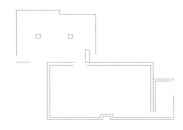

26 RENEE COX
Chillin with Liberty, 1998
C-print
60 x 40" edition of 3
courtesy Robert Miller Gallery,
New York, NY

27 LEON GOLUB
Wasted Youth I, 1994
silkscreen
44 1/2 x 33 5/8"
edition of 75

28 EDUARDO KAC
Free Alba! (Folha de São Paulo), 2002
color photograph mounted on aluminum
46 1/2 x 36"
courtesy Julia Friedman, Chicago, IL

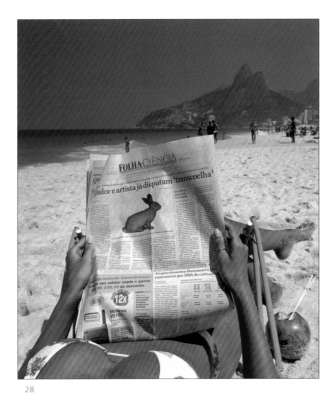

28

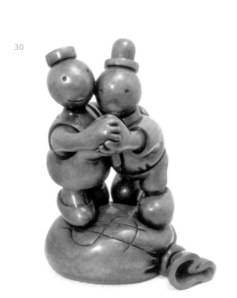

29

30

31

29 **TOM JEZEK**
Untitled, 2003
plastic objects, labels,
metal shopping cart
14 x 14 x 9" overall

30 **TOM OTTERNESS**
Free Money, 1999
bronze
36 x 27 x 20" edition of 6
courtesy Marlborough Gallery, New York, NY

31 **TOM OTTERNESS**
Big Thief, 2001
bronze
10 x 9 1/2 x 9 1/2" edition of 6
courtesy Marlborough Gallery, New York, NY

INFECTIONS OF SARS, DIES IN A HONG KONG HOSPITAL —2003 MARCH 5 BRITISH SENTRIES GUARDING THE BOSTON CUSTOMS

ALTHOUGH THE LIBRARY HERE AT AMERI©AN DRE@M MAKES EVERY EFFORT TO PROTECT YOUR PRIVACY, UNDER THE FEDERAL USA PATRIOT ACT (PUBLIC LAW 107-56), RECORDS OF THE BOOKS AND OTHER MATERIALS YOU BORROW MAY BE OBTAINED BY FEDERAL AGENTS. THIS SAME FEDERAL LAW PROHIBITS OUR WORKERS FROM INFORMING YOU IF FEDERAL AGENTS HAVE INDEED OBTAINED RECORDS ABOUT YOU.

PLEASE DIRECT ALL QUESTIONS REGARDING THIS POLICY TO:

ATTORNEY GENERAL JOHN ASHCROFT
DEPARTMENT OF JUSTICE
WASHINGTON, DC 20530

bringing the american dream to you

.02 31 MERCER STREET

north gallery

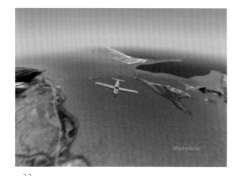

32

34

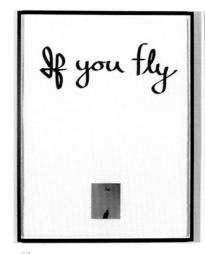

33

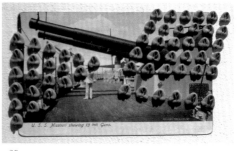

35

32 JOHN WHITE C
 Flight Simulator/Travelog, 1998
 digital software, CD ROM
 installation dimensions variable edition of 2
 courtesy Monique Meloche Gallery, Chicago, IL
 collection of Martina Batan

33 CHRIS BURDEN
 If You Fly – If You Drive, 1973
 lithographs, diptych
 31 1/2 x 23 1/2" each (F)
 edition of 50

34 PEPON OSORIO
 I-95 (detail), 2001
 mixed media
 45 3/4 x 31 5/8 x 5 1/2" (F)
 edition of 30

HOUSE SHOOT INTO A CROWD KILLING FOUR INCLUDING CRISPUS ATTICUS, AN AFRICAN-AMERICAN SAILOR, THE FIRST AMERICAN

36

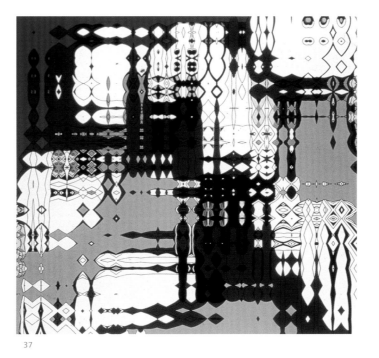

37

38

35	HANNAH WILKE	36	PAUL PFEIFFER	37	CARL FUDGE	38	ELLEN LEVY

35 HANNAH WILKE
U.S.S. Missouri, 1977
kneaded eraser, vintage postcard
on painted wood
16 x 18 x 2"

36 PAUL PFEIFFER
Goethe's Message to the New Negroes, 2001
metal armature, miniature monitor, DVD and DVD player
5 1/2 x 6 1/2 x 60" edition of 6
courtesy The Project, New York, NY and Los Angeles, CA

37 CARL FUDGE
They're Everywhere, 2002
screenprint
37 3/8 x 39 3/8"
edition of 27

38 ELLEN LEVY
Missiles + Monuments, 2002
digital prints, diptych
90 x 12" each (F)

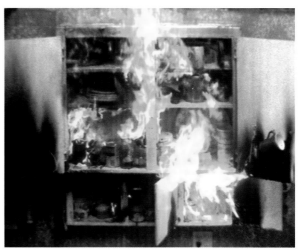
41

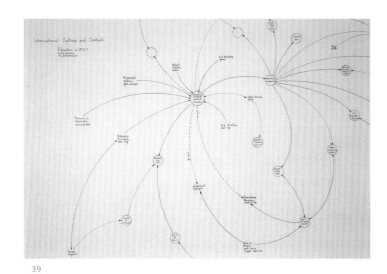

39

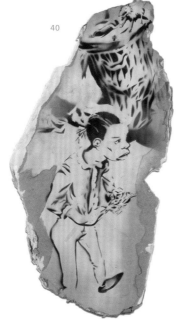
40

39 MARK LOMBARDI
International System and Controls,
Houston, c.1972-77 (detail), 1997
graphite on paper
30 x 60" (F)
courtesy Pierogi 2000, Brooklyn, NY

40 JAMES ROMBERGER
Bubbles, c.1980's
spray paint on Sheetrock fragment
42 x 20 1/2"
collection of Ken Moss

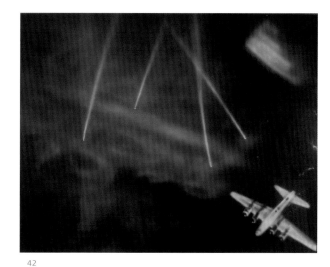

42

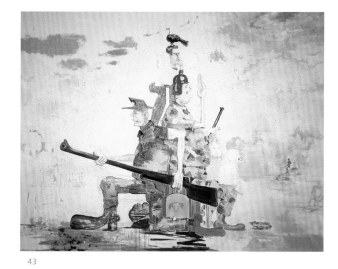

43

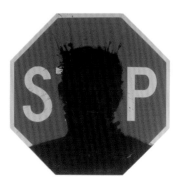

44

41 REYNOLD REYNOLDS & PATRICK JOLLEY
Burning Cabinet, 2002
(moving) picture sculpture
edition of 5

42 JACK GOLDSTEIN
Untitled Painting #43, 1981
acrylic on masonite
48 x 60" (F)
collection of Martina Batan
and David Clarkson

43 DAVID SCHER
Time is Now, 2002
oil on canvas
64 x 82"
courtesy Leo Koenig, Inc.,
New York, NY

44 RICHARD HAMBLETON
Stop Signs, 1979 (two works)
metal stop signs with mixed media
24 x 24" each
collection of Ken Moss

MARCHING FROM SELMA, ALABAMA TO THE STATE CAPITOL IN MONTGOMERY IN SUPPORT OF AFRICAN AMERICAN VOTING RIGHTS,

46

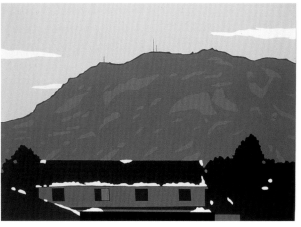

47

45

45 DREW DOMINICK
 Canada Geese, 2001
 bronze
 9 1/2 x 12 x 6"
 edition of 3

46 ROBYN O'NEIL
 Snow Scene (Miami Dave and Teddy Hansen), 2003
 graphite on paper
 17 1/2 x 24 3/4"
 courtesy Bodybuilder & Sportsman, Chicago, IL

47 DAVID CLARKSON
 *Cheyenne Mountain, Colorado
 (NORAD/U.S. Space Command)*, 2001
 acrylic on canvas
 36 x 48"

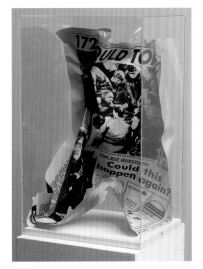

49

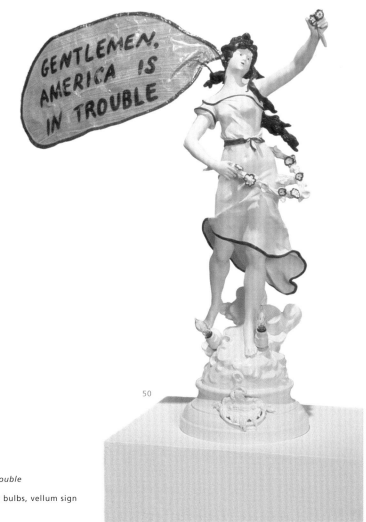

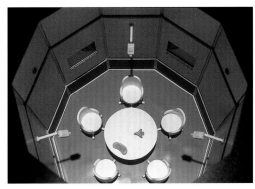

48

50

48 MIKE SMITH
Conference Room, 2003
(overhead view)
mixed media sculpture
15 x 15 x 16 1/2"
courtesy Bodybuilder & Sportsman, Chicago, IL

49 ANDY WARHOL
New York Post Headliner,
October 24, 1983, 1984
unique silkscreen on metal sheet
20 1/2 x 12 x 10"
Private Collection

50 IDA APPLEBROOG
Gentlemen, America is in Trouble
(after A. Moreau), 1982
painted plaster statue, light bulbs, vellum sign
30 x 23 x 9"
Private Collection

World famous artists Christo and Jeanne-Claude, are pleased to announce a new project that is slated to begin immediately. Responding to United States Homeland Defense Secretary Tom Ridge's call for artists to rally the cause through anti-terrorist art, Christo has received permission to wrap the White House in Washington, DC, using duct tape and plastic sheeting. Much like the artist's 1995 project, "Wrapped Reichstag" in Berlin, "Wrapped White House" will, according to the artists' plan, seal the building and those inside. Of the project the artists said, "We are very excited to use our art making methods in the international fight against terrorists. By wrapping the White House we hope to help keep terrorism under wraps, so to speak." Unlike "Wrapped Reichstag" which was a temporary project, "Wrapped White House" will be the artists first permanent work of public art.

100,000 square meters (1,076,000 square feet) of clear high-strength polypropylene plastic and 15,600 meters (51,181 feet) of silver duct tape, 13.2 cm (4 inch) wide, will be used for the wrapping of the White House. The work will be completed in as little as one week. The artists have contacted other artists across the US who are now en route to Washington in order to finish this work in record time. Materials have been provided without charge by the German government. Recalling the "Wrapped Reichstag," German Chancellor Gerhard Schroder stated, "Wrapping the symbol of German Democracy was a defining moment for the new Germany. Wrapping the White House will be a defining moment as democracy is restored in America."

anonymous* email

*OUR RESEARCH DEPARTMENT HAS DETERMINED THAT ANONYMOUS IS ACTUALLY SEATTLE ARTIST, JACK MACKIE

03 419 BROOME STREET

upstairs

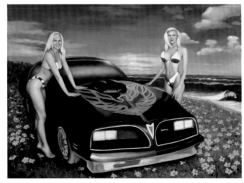

52

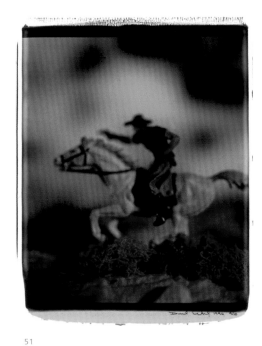

51

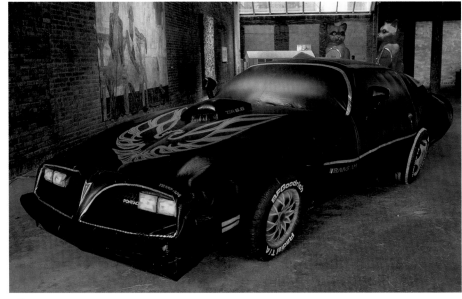

53

51 DAVID LEVINTHAL
 Untitled (Wild West Series), 1996
 Polaroid Polacolor ER land film
 24 x 20"

52 GUY OVERFELT
 Untitled (Painting no. 069), 1998-2003
 oil on linen
 32 x 42"

53 GUY OVERFELT
 Untitled (Trans AM), 2000-2003
 inflated nylon, paint and motor
 8 x 16 x 5'

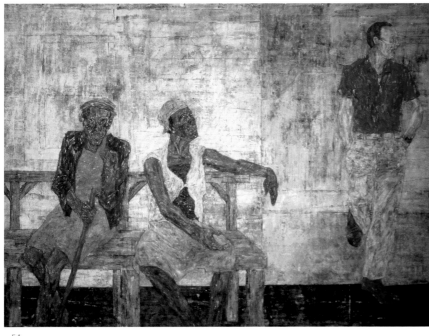

54

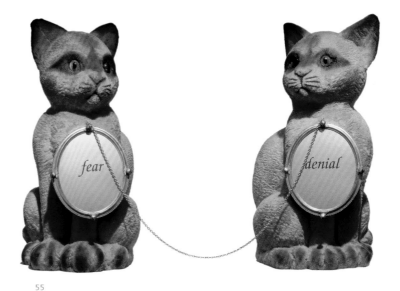

55

54 LEON GOLUB
 *Two Black Women
 and a White Man*, 1986
 acrylic on linen
 120 x 163"
 Private Collection

55 PEPON OSORIO
 Fear and Denial, 1997
 mixed media sculpture
 92 x 96 x 32"
 collection of Brooklyn Museum of Art,
 Brooklyn, NY

NEW YORK TIMES REPORTS A CARP SHOUTING IN HEBREW AT THE NEW SQUARE FISH MARKET IN NEW YORK —2003 MARCH 16 JAMES

58

56

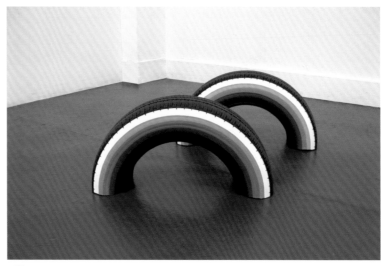

57

56 BRUCE PEARSON
*Why can't love come
in a six pack?*, 1999
oil and acrylic on Styrofoam
96 x 72 x 6"
Private Collection

57 ANISSA MACK
Grey Rainbow (Double), 2002
painted tires
11 x 22 x 7" each
edition of 3

58 TOM FRIEDMAN
Untitled, 2000
inkjet print
21 1/2 x 41 1/4" (F)
edition of 100
courtesy Feature, Inc., New York, NY

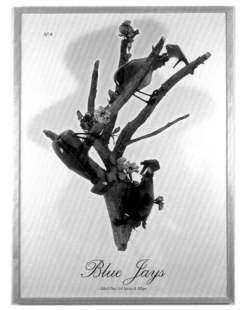

60

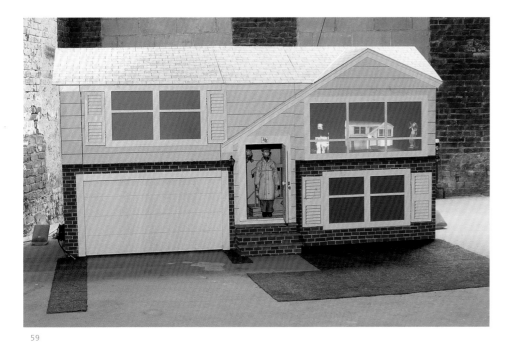

59

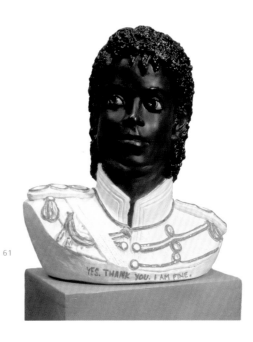

61

59 DAN HURLIN
*The Home of Bill and
Sandy Kelly,* 2000
mixed media installation
variable dimensions

60 HEIDI CODY
Blue Jays, 2002
Duraflex print
39 7/8 x 29 7/8 (F) edition of 10
courtesy Roebling Hall, Brooklyn, NY

61 IDA APPLEBROOG
Yes. Thank you. I am fine., 2003
painted plaster statue
17 1/2 x 16 x 13"

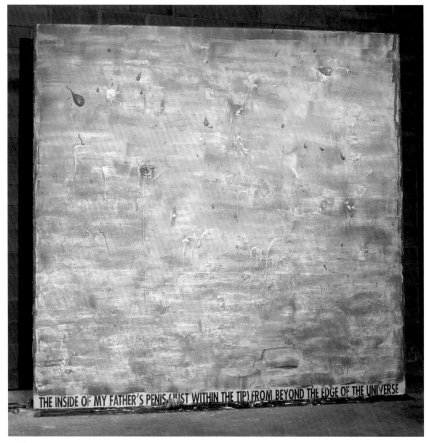

62

THE INSIDE OF MY FATHER'S PENIS (JUST WITHIN THE TIP) FROM BEYOND THE EDGE OF THE UNIVERSE

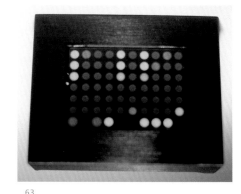

63

62 WILLIAM POPE. L
 Universal Painting, 2002-2003
 wallboard, peanut butter, latex paint,
 fabric, vinyl lettering
 10 x 10'

63 JENNY HOLZER
 Inflammatory Essays-1, 1979-82
 mini LED sign
 4 x 4 7/8 x 1/2" edition of 100
 courtesy Cheim & Read, New York, NY

64 HOMER AVILA
 Without Words, 2001
 performance video
 3 minute 30 second segment

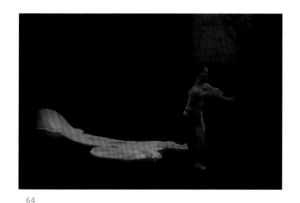

64

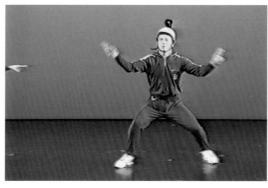

65

66

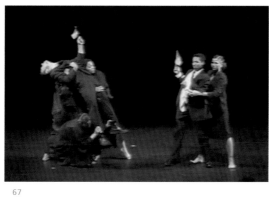

67

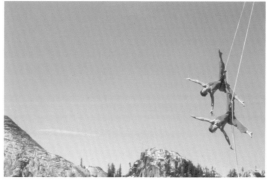

68

65 HEADLONG DANCE THEATER
(Andrew Simonet, Amy Smith & David Brick)
Car Alarm, 1997
performance video
5 minute 43 second segment

66 TRACIE MORRIS
Power is Sweet, 2002
performance video
1 minute 23 second segment

67 JANE COMFORT
*A Better Man for a
Better America*, 1998
performance video
5 minute 1 second segment

68 AMELIA RUDOLPH
Crossing, 2002
performance video with
Amelia Rudolph and Rachael Lincoln
1 minute 50 second segment

PRESIDENT BUSH SHOULD RESIGN INSTEAD —2003 MARCH 19 THE NEW YORK TIMES ANNOUNCES THAT PAINTER JACK GOLDSTEIN

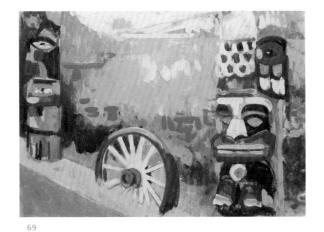

69

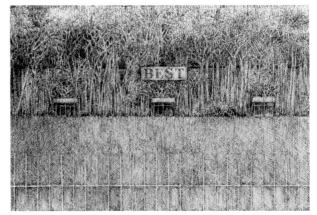

70

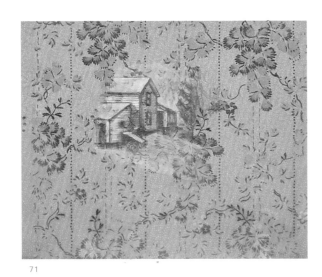

71

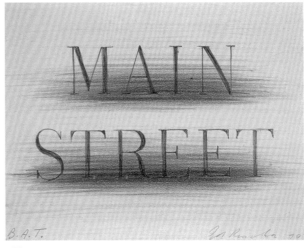

72

69 GORDON VOISEY
 Totems, 2000
 oil on canvas
 22 1/2 x 30 1/4"

70 SITE
 Best Richmond Showroom, 1978
 ink on paper
 14 x 19" (F)
 Private Collection

71 YVONNE PUFFER
 Wallpaper Drawing #6 (farmhouse), 2003
 pencil and acrylic on de-acidified wallpaper
 10 x 12" (F)
 courtesy Margarete Roeder Gallery,
 New York, NY

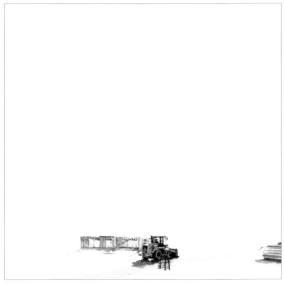

74

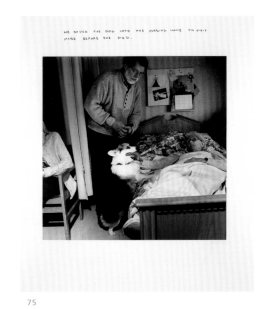

75

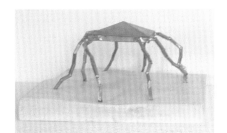

73

72 ED RUSCHA
 Main Street, 1990
 lithograph
 8 1/4 x 10 1/4" (F) edition of 250
 courtesy Gemini G.E.L Gallery,
 New York, NY

73 ALLAN WEXLER
 Building with Eight Columns, 1997
 aluminum, emulsion modeling paste,
 chipboard, plaster
 6 1/2 x 11 x 14"

74 CHRIS DOYLE
 Untitled House Series, 2001
 watercolor on paper
 9 x 9"
 courtesy Jessica Murray Projects,
 Brooklyn, NY

75 CHRIS VERENE
 Untitled (Galesburg #58), 1999-2000
 "We snuck the dog in to see Mabe
 in the nursing home before she died."
 C-print and ink
 26 1/2 x 22 1/2" (F) edition of 20

BAGHDAD WHERE SADDAM HUSSEIN AND TOP AIDES ARE BELIEVED TO BE, AND GROUND WAR BEGINS NEAR KUWAITI BORDER —2003

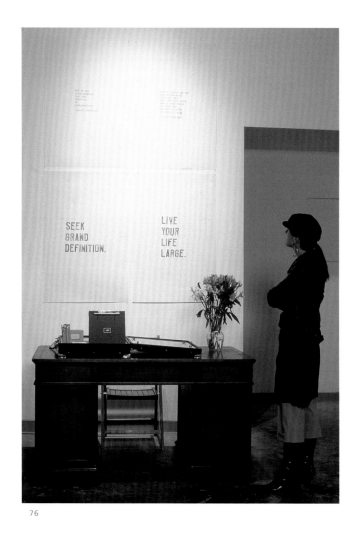

SEEK
GRAND
DEFINITION.

LIVE
YOUR
LIFE
LARGE.

76

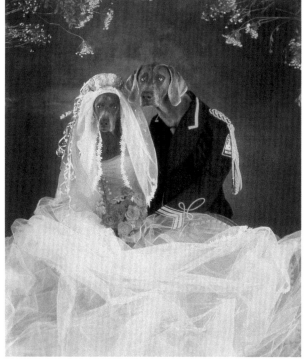

77

76 CHRISTINE HILL
The Volksboutique Stamp Kit, 2001
installation photo
handmade case, rubber stamp alphabets, titanium camera, gummed labels,
record book, stamp ink, stationery ephemera, Volksboutique embosser and
pencils, clipboard, templates, tip jar, business cards.

77 WILLIAM WEGMAN
Bride and Groom (from the *Cinderella* portfolio), 1994
photolithograph
27 1/2 x 23 1/2"
edition of 120

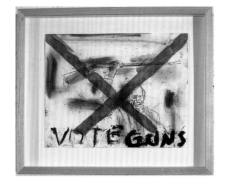

78

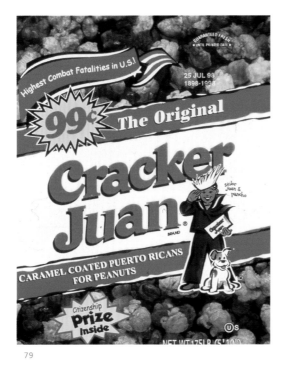

79

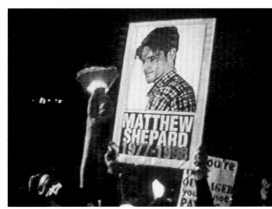

80

78 LEON GOLUB
 Vote Guns, 2002
 oil stick and acrylic on paper
 8 x 10"
 Private Collection

79 MIGUEL LUCIANO
 Cracker Juan, 1998
 archival inkjet print
 24 x 18"
 edition of 50

80 ELAINE ANGELOPOULOS
 Matthew Shepard 1977-1998 from
 Matthew Shepard Vigil in NYC, 10/19/98, 1999
 C-prints from a set of 16 video stills
 11 x 14"

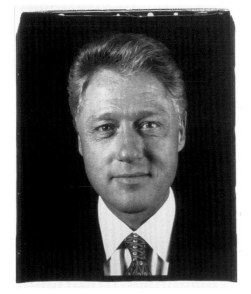

81

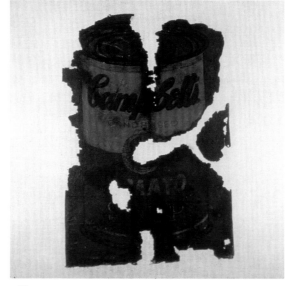

83

84

82

85

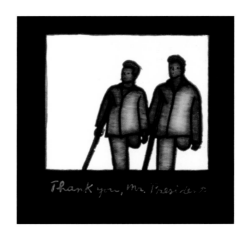

87

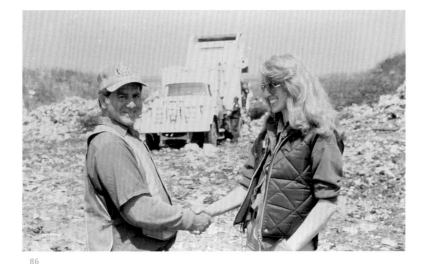

86

84 ANNE JOSEPH
 September 11, Brooklyn, 2001
 C-print
 14 x 11"
 courtesy the Alliance for
 Young Artists and Writers, Inc.

85 MIERLE LADERMAN UKELES
 Fresh Kills, 2001
 C-print
 9 1/2 x 24"
 edition of 5

86 MIERLE LADERMAN UKELES
 Landfill from *Touch Sanitation,*
 a city-wide performance with 8,500
 NYC Sanitation workers, 1978-80
 1 of 6 C-prints
 20 x 24" edition of 3

87 IDA APPLEBROOG
 Thank you, Mr. President (detail), 1983
 enamel and rhoplex on canvas
 12 x 60"
 Private Collection

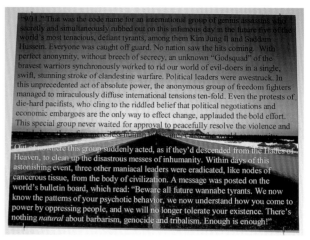

89

"9/11." That was the code name for an international group of genius assassins who secretly and simultaneously rubbed out on this infamous day in the future five of the world's most tenacious, defiant tyrants, among them Kim Jung Il and Saddam Hussein. Everyone was caught off guard. No nation saw the hits coming. With perfect anonymity, without breech of secrecy, an unknown "Godsquad" of the bravest warriors synchronously worked to rid our world of evil-doers in a single, swift, stunning stroke of clandestine warfare. Political leaders were awestruck. In this unprecedented act of absolute power, the anonymous group of freedom fighters managed to miraculously diffuse international tensions ten-fold. Even the protests of die-hard pacifists, who cling to the riddled belief that political negotiations and economic embargoes are the only way to effect change, applauded the bold effort. This special group never waited for approval to peacefully resolve the violence and

Out of nowhere this group suddenly acted, as if they'd descended from the Hades of Heaven, to clean up the disastrous messes of inhumanity. Within days of this astonishing event, three other maniacal leaders were eradicated, like nodes of cancerous tissue, from the body of civilization. A message was posted on the world's bulletin board, which read: "Beware all future wannabe tyrants. We now know the patterns of your psychotic behavior, we now understand how you come to power by oppressing people, and we will no longer tolerate your existence. There's nothing *natural* about barbarism, genocide and tribalism. Enough is enough!"

FEAR IS THE MOST ELEGANT WEAPON, YOUR HANDS ARE NEVER MESSY. THREATENING BODILY HARM IS CRUDE. WORK INSTEAD ON MINDS AND BELIEFS, PLAY INSECURITIES LIKE A PIANO. BE CREATIVE IN APPROACH. FORCE ANXIETY TO EXCRUCIATING LEVELS OR GENTLY UNDERMINE THE PUBLIC CONFIDENCE. PANIC DRIVES HUMAN HERDS OVER CLIFFS. AN ALTERNATIVE IS TERROR-INDUCED IMMOBILIZATION. FEAR FEEDS ON FEAR. PUT THIS EFFICIENT PROCESS IN MOTION. MANIPULATION IS NOT LIMITED TO PEOPLE. ECONOMIC, SOCIAL AND DEMOCRATIC INSTITUTIONS CAN BE SHAKEN. IT WILL BE DEMONSTRATED THAT NOTHING IS SAFE, SACRED OR SANE. THERE IS NO RESPITE FROM HORROR. ABSOLUTES ARE QUICKSILVER, RESULTS ARE SPECTACULAR.

88

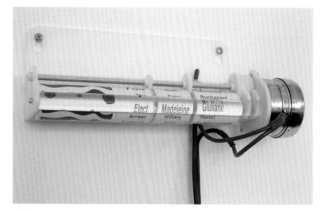

90

88 JENNY HOLZER
*Inflammatory Essays: Fear is
the most elegant weapon...*, 1979-82
pencil on tracing paper
24 x 65 3/4" (F)
courtesy Cheim & Read, New York, NY

89 TODD SILER
*American Dream: Responses
to Terror*, 2003
photo laser print
23 x 30"

90 DAVID OPDYKE
Electioneering, 2001
motor, laser cut acrylic, vinyl signage
3 x 8 x 3"
courtesy Roebling Hall, Brooklyn, NY

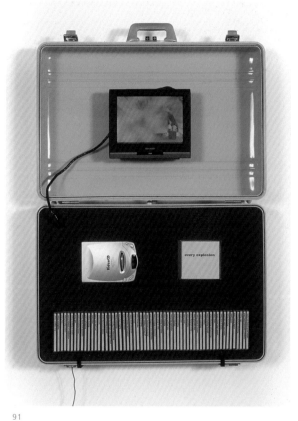

91

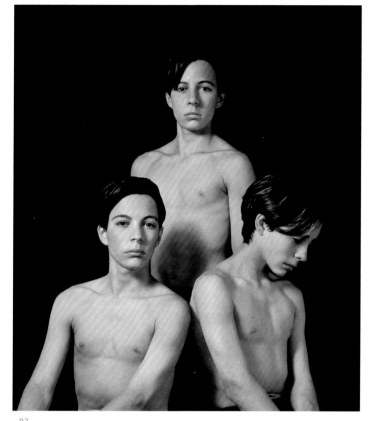

92

91	JENNIFER & KEVIN MCCOY	92	KEITH COTTINGHAM

91 JENNIFER & KEVIN MCCOY
 Every Anvil, 2001
 mixed media electronics
 42 x 29 x 7'
 courtesy Jeffrey Dachis

92 KEITH COTTINGHAM
 Fictitious Portrait (Triple), 1993
 digitally constructed photograph
 from a series of 3
 61 1/2 x 53 1/4" (F) edition of 7

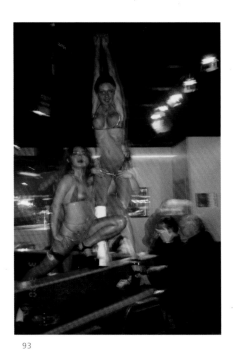

93

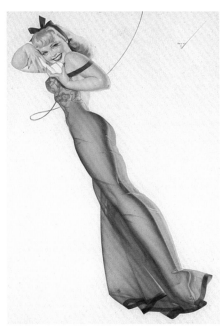

94

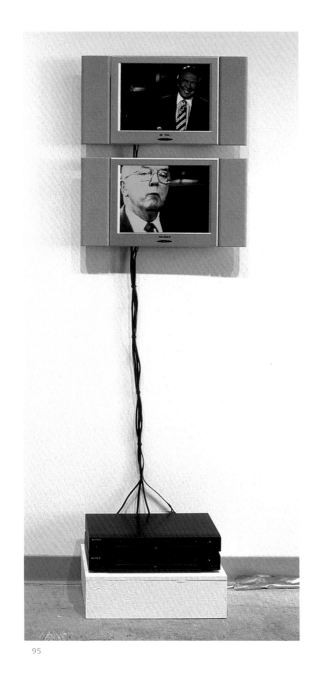

95

93 NIKKI S. LEE
 The Exotic Dancers Project (33), 1999
 Fijiflex print
 40 x 30" edition of 3
 courtesy Leslie Tonkonow Artworks +
 Projects, New York, NY

94 GEORGE PETTY
 True, November 1947, 1947
 pen, ink, gouache,
 watercolor on board
 24 1/2 x 18 1/4"
 Private Collection

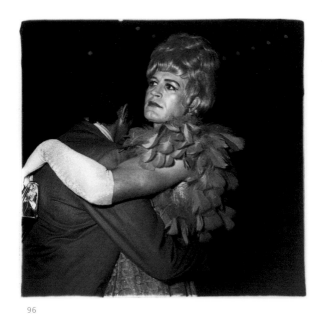

96

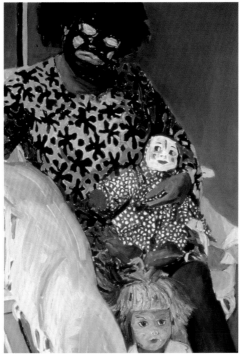

97

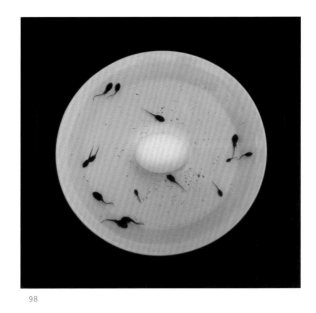

98

95 JANE PHILBRICK
 Oh, God!, 2003
 A Wife Has a Cow, 2003
 an excerpt from "Re-Spoken" a work in progress
 2 LCD screens, 2 DVDs, 2 DVD players
 edition of 3

96 DIANE ARBUS
 Two Men Dancing at a Drag Ball, NYC, 1970
 gelatin silver print
 20 x 16" edition of 75
 courtesy Robert Miller Gallery, New York, NY

97 BEVERLY MCIVER
 Molly Resting with
 Her Favorite Mammy, 1998
 oil on canvas
 48 x 36"

98 NINA KATCHADOURIAN
 Artificial Insemination #3, 1998
 C-print
 20 x 20" edition of 5
 courtesy Debs & Co., New York, NY

SALES BY HOOK

RACE
RELIGION
INCOME
AGE
SEX

SALES BY CROOK

RACE
RELIGION
INCOME
AGE
SEX

SALES BY BAIT

RACE
RELIGION
INCOME
AGE
SEX

SALES BY SWITCH

RACE
RELIGION
INCOME
AGE
SEX

WHAT YOU CAN COUNT ON

SEP OCT NOV DEC JAN FEB MAR APR MAY JUN

financial statement

STATISTICAL DATA BY SHOCK & AWE MARKETING, INC.

04 419 BROOME STREET

downstairs

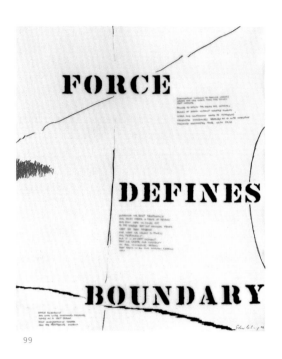

99

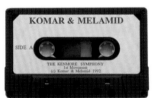

100

101

99 EDWIN SCHLOSSBERG
Force Defines Boundary, 2002
ink and graphite on vellum
48 1/4 x 40 1/4 x 5 1/4"

100 KOMAR & MELAMID
Kenmore Symphony, 1990-92
audiocassette tape
4 1/4 x 2 3/4 x 5/8"
unlimited edition

101 MICHAEL W. WILSON
Headshot, 2003
lightjet print
30 x 24" (F)
edition of 10

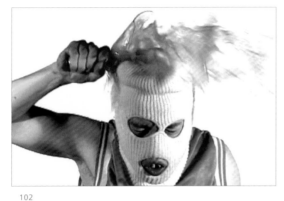

102

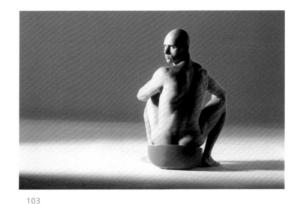

103

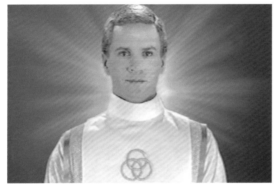

104

105

102 MOMBERT
One Hit Wonder, 2002
digital video transfer to VHS
approximately 15 minutes

103 JIM ANDERSON
Bliss Jag, 1995
video from a multi media installation
approximately 4 minutes

104 BJØRN MELHUS
The Oral Thing, 2001
DVD, 8 minutes edition of 8
Realized in co-production with NBK Berlin
courtesy Galerie Anita Beckers, Frankfurt;
Roebling Hall, Brooklyn, NY

105 CHRISTOPHER DRAEGER,
REYNOLD REYNOLDS & GARY BRESLIN
The Last News, 2002
DVD starring Guy Richards Smit
13 minutes edition of 5
courtesy Roebling Hall, Brooklyn, NY;
Mullerdechiara, Berlin; Anne de Villepoix, Paris

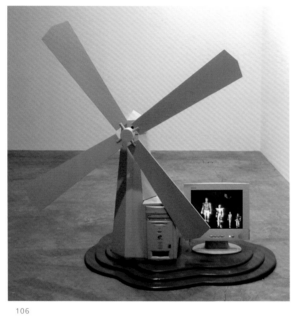

106

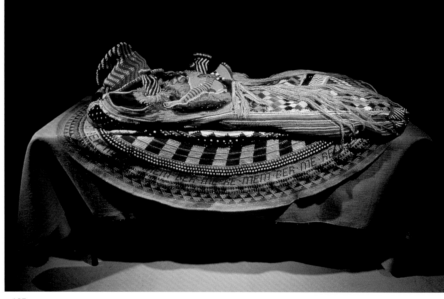

107

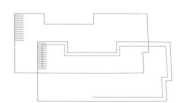

106 EDDO STERN
Crusade, 2002
mixed media sculpture
60 x 48 x 36"

107 XENOBIA BAILEY
Paradise Under Reconstruction and the Aesthetic of Funk,
Next Phase, Life after Death (An Open Memorial), 2002
crochet, acrylic, cotton, plastic pony beads and embroidery
courtesy Stefan Stux Gallery, New York, NY
17 x 73"

108 ®™ARK
Foodbomb, 2003
steel, nylon, food
36 x 24 x 24"
plus parachute

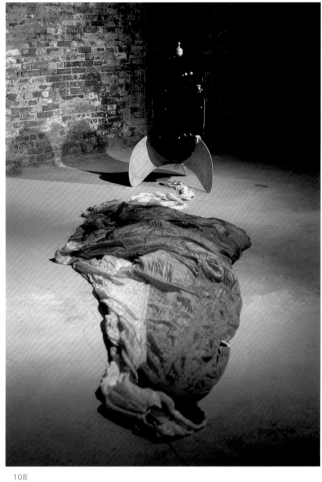

108

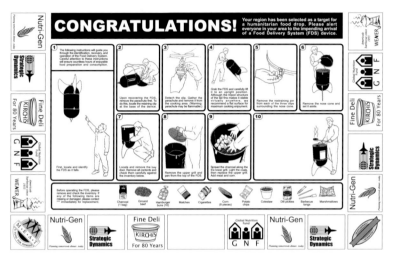

109

109 ®™ARK
Foodbomb Instructions, 2003
Xerox reproduction
Illustrated by Matthew McElligott
21 1/2 x 33 7/16"

110

111

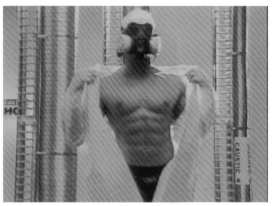

112

110 RICO GATSON
 Gun Play, 2001
 DVD
 2 minutes 35 seconds
 edition of 5

111 TODD DOWNING
 Jeffrey's Hollywood
 Screen Trick, 2002
 film excerpt on video
 10 minutes 54 seconds

112 JIM ANDERSON
 Trace Elements, 1994
 1 video from multi media installation
 approximately 8 minutes

A REMOTE MONTANA CABIN -1996 APRIL 4 MARTIN LUTHER KING, JR. IS ASSASSINATED IN MEMPHIS, TENNESSEE -1968

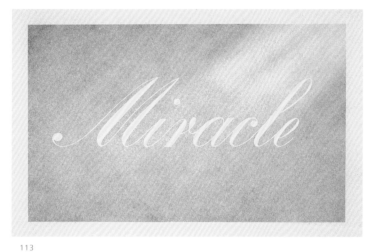

113

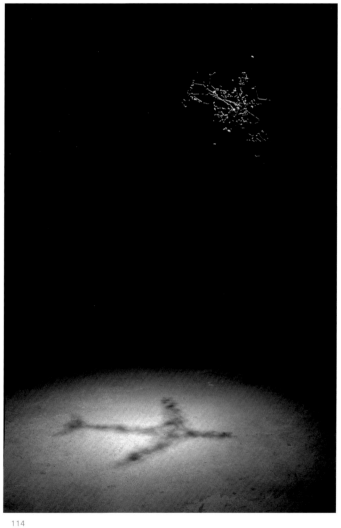

114

113 ED RUSCHA
Miracle, 1999
lithograph
23 1/2 x 32 1/4" (F) edition of 60
courtesy Gemini G.E.L Gallery, New York, NY

114 DAVID OPDYKE
Aviation Agglomeration, 2001
plastic, steel, light
15 x 15 x 15"
Private Collection

AMERI©AN DRE@M, AMERICAN IDIOMS SCREENING SERIES
Thursday, March 27th and Thursday, April 3rd

The following programs of short films were organized in conjunction with AMERI©AN DRE@M.
The films were selected by John Hanhardt and Maria-Christina Villasenor, the Senior and Associate
Curators of Film and Media Arts for the The Solomon R. Guggenheim Museum in New York.

PROGRAM ONE: AMERI©AN DRE@MS (AMERIC@N NIGHTMARES)
Thursday, March 27th

In meditative experimental works and probing short documentaries, the artists reflect on a crisis of meaning, focusing directly
and indirectly on American structures of power, the rhetoric of war and militarization, and constructions of nationalism.

Life or Liberty by Konrad Aderer
73 Suspect Words by Peggy Ahwesh
The Imagined, The Longed-For, The Conquered and The Sublime by Roddy Bogawa
Now Let Us Praise American Leftists by Paul Chan
Losing Ground by Patty Chang
Evil by Tony Cokes
Language Lessons by Jeanne Finley
Flag TV by Susie Lee
The Free Space of the Commodity by Les Leveque
The Art of Protective Coloration by Sherry Milner/Ernest Larsen
1, by Shelly Silver

PROGRAM TWO: AMERI©AN DRE@MS (AMERIC@N OBSESSIONS)
Thursday, April 3rd

The great American pastime of obsessive behavior is chronicled in a range
of satirical short narratives and mixed-genre experimental works.

Estranged by Todd Downing
Loss Prevention by Jeanne Finley
Final Exit by Joe Gibbons
Grandma Cooks by Christina Ibarra
Levels by Jon Jolles
The Amateurist by Miranda July
The Great Yiddish Love by Diane Nerwen
Las Papas del Papa by Alex Rivera

AMERI©AN DRE@M, TEXT WORKS

EDWIN SCHLOSSBERG, p. 34

BEWARE: AN AMERICAN DREAMS FOR US

Fulltext: Copyright 2000 Federal News Service, Inc.

Federal News Service

December 18, 2000, Monday

SECTION: WHITE HOUSE BRIEFING

LENGTH: 2535 Words

HEADLINE: PRESS AVAILABILITY WITH PRESIDENT-ELECT GEORGE W. BUSH AND HOUSE AND SENATE BIPARTISAN LEADERS FOLLOWING THEIR MEETINGS

PARTICIPANTS: HOUSE SPEAKER DENNIS HASTERT (R-IL) SENATE MAJORITY LEADER TRENT LOTT (R-MS) SENATE MINORITY LEADER TOM DASCHLE (D-SD) AND HOUSE MINORITY LEADER DICK GEPHARDT (D-MO)

LOCATION: THE CAPITOL, WASHINGTON, D.C.

BODY: PRESIDENT-ELECT BUSH: Thank you all for coming. I just made my rounds to the leaders here on the Hill. I want to thank all four for their hospitality and their gracious reception of the newly elected president. I made it clear to each that I come to Washington with the intention of doing the people's business; that I look forward to listening, and occasionally talking; to work with both the Republicans and the Democrats.

I told all four that I felt like this election happened for a reason; that it pointed out—the delay in the outcome should make it clear to all of us that we can come together to heal whatever wounds may exist, whatever residuals there may be. And I really look forward to the opportunity. I'm—I hope they've got my sense of optimism about the possible, and enthusiasm about the job.

I told all four that there are going to be some times where we don't agree with each other, but that's okay. If this were a dictatorship, it would be a heck of a lot easier. (Chuckles.) (Laughter.) Just so long as I'm the dictator. (Laughter.)

But I'm excited. I'm excited about the potential, and I'm excited about what we can do together for America. It's a great honor to be here. Again, I want to thank you all very much for your kindness and your hospitality, Mr. Speaker.

Not quite through yet, Carl (sp).

JENNY HOLZER, p. 36

Fear is the most elegant weapon. Your hands are never messy. Threatening bodily harm is crude. Work instead on minds and beliefs, play insecurities like a piano. Be creative in approach. Force anxiety to excruciating levels or gently undermine the public confidence. Panic drives human herds over cliffs. An alternative is terror-induced immobilization. Fear feeds on fear. Put this efficient process in motion. Manipulation is not limited to people. Economic, social and democratic institutions can be shaken. It will be demonstrated that nothing is safe, sacred or sane. There is no respite from horror. Absolutes are quicksilver. Results are spectacular.

TODD SILER, p.36

"9/11." That was the code name for an international group of genius assassins who secretly and simultaneously rubbed out on this infamous day in the future five of the world's most tenacious, defiant tyrants, among them Kim Jung II and Saddam Hussein. Everyone was caught off guard. No nation saw the hits coming. With perfect anonymity, without breech of secrecy, an unknown "Godsquad" of the bravest warriors synchronously worked to rid our world of evil-doers in a single, swift, stunning stroke of clandestine warfare. Political leaders were awestruck. In this unprecedented act of absolute power, the anonymous group of freedom fighters managed to miraculously diffuse international tensions ten-fold. Even the protests of die-hard pacifists, who cling to the riddled belief that political negotiations and economic embargoes are the only way to effect change, applauded the bold effort. This special group never waited for approval to peacefully resolve the violence and social chaos those five merciless human hurricanes cause the world community. Out of nowhere this group suddenly acted, as if they'd descended from the Hades of Heaven, to clean up the disastrous messes of inhumanity. Within days of this astonishing event, three other maniacal leaders were eradicated, like nodes of cancerous tissue, from the body of civilization. A message was posted on the world's bulletin board, which read: "Beware all future wannabe tyrants. We now know the patterns of your psychotic behavior, we now understand how you come to power by oppressing people, and we will no longer tolerate your existence. There's nothing *natural* about barbarism, genocide and tribalism. Enough is enough!"

ACKNOWLEDGMENTS

We would like to thank all the artists who participated in AMERI©AN DRE@M, as well as the private collectors who lent works for the exhibition, including Stephen Abronson, Martina Batan, David Clarkson, Greg S. Feldman, and Ken Moss.

The following galleries deserve special recognition for their assistance and cooperation:

In New York: Alliance for Young Artists & Writers, Inc., Cheim & Read, Debs & Co, Feature, Inc., Gemini G.E.L., Leo Koenig, Inc., Marlborough Gallery, Robert Miller Gallery, Jessica Murray Projects, Pierogi 2000, The Project, Roebling Hall, Margarete Roeder Gallery, Julie Saul Gallery, Stefan Stux Gallery, Leslie Tonkonow Artworks + Projects.

In Chicago: Bodybuilder & Sportsman Gallery, Julia Friedman Gallery, Monique Meloche Gallery, Zolla/Lieberman Gallery.

In San Francisco: Fraenkel Gallery.

We gratefully acknowledge the Creative Capital Foundation and Ruby Lerner, Executive Director, for providing information about its outstanding fellowship program, Lynn Cassaniti for technical assistance in preparing the video and film pieces, and John Hanhardt and Maria-Christina Villasenor of the Solomon R. Guggenheim Museum for curating the Thursday night film and video programs.

We appreciate the cooperation, enthusiastic support, and tireless effort of the staff at Ronald Feldman Fine Arts: Jennifer Aborn, Kathleen Agnoli, Steve Butz, Thad Cary, Andrew Coppola, Pedro Cruz-Castro, Peggy Jarrell Kaplan, Jenna Komarin, Emily Poole, and the freelancers: Kane Austin, Jack Dishel, Michal-Ann McElhany, Jason Mombert, Robert Rogan, and Kelly Welburn.

Special thanks to Marco Nocella and Frayda Feldman.

PHOTOGRAPHY CREDITS

All photos copyright of the artists and courtesy of the galleries that lent the works with the following exceptions:

pl. 35, © 2003 Donald Goddard
pl. 72, © Gemini G.E.L., Los Angeles, California, 1990
pl. 113, © Gemini G.E.L., Los Angeles, California, 1999
pl. 96, Copyright © Estate of Diane Arbus, LLC 1970
pls. 63, 88, © 2003 Jenny Holzer/Artists Rights Society (ARS), New York
pls. 24, 49, © 2003 Andy Warhol Foundation for the Visual Arts/Artists Rights Society (ARS), New York

Photos of the following works were taken by D. James Dee: pls. 23, 49, 77, 81, 87, 99; Hermann Feldhaus: 37; John Lamka: 1, 35, 55; Mark Luttrell: 31; David Reynolds: 54; Corey Rich: 68; Oren Slor: 58; Zindman/Fremont: 2, 7, 10, 11, 22, 34, 39, 40, 42, 44, 50, 53, 56, 59, 61, 62, 75, 76, 89, 94, 95, 100, 107, 108, 114.